Whispers in a stone circle.

Glimpses of eternity upon Ale stones.

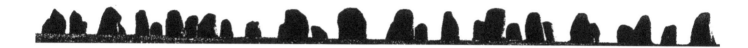

Whispers in a stone circle

Glimpses of eternity upon Ale stones.

Somerled Karlsson

Step into the world of Ale's Stones and Kåseberga through this captivating photobook!

This book takes you on a visual journey to one of Sweden's most fascinating locations. Through captivating photographs, you will experience the enigmatic ship setting of Ale stenar and the quaint fishing village of Kåseberga on Österlen. Delve into the historical and cultural significance of this extraordinary place. Let its beauty and charm inspire you.

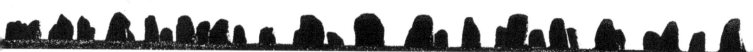

Kåseberga is a small fishing village situated on the southern coast of Sweden in Skåne. It lies between Ystad and Simrishamn. The village is renowned for its remarkable ancient monument, Ale stenar, but it also boasts a vibrant history and a delightful present.

Kåseberga has a rich history that dates back to the Viking Age. Throughout the centuries, it has served as a significant fishing port and trading hub, playing a crucial role in commerce and maritime activities.

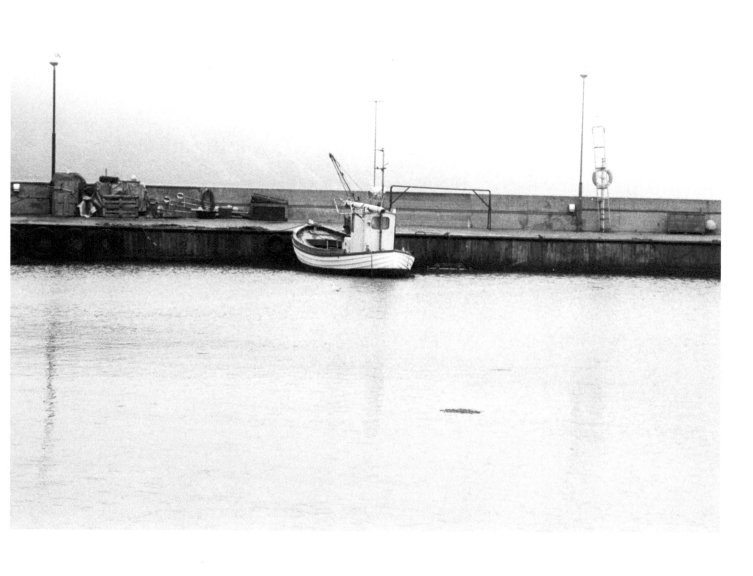

One of the primary highlights of Kåseberga is its picturesque fishing village. Additionally, the village is renowned for its smoked fish, a delicacy in the region of Scania. Visitors have the opportunity to savor this local specialty at various restaurants in the area.

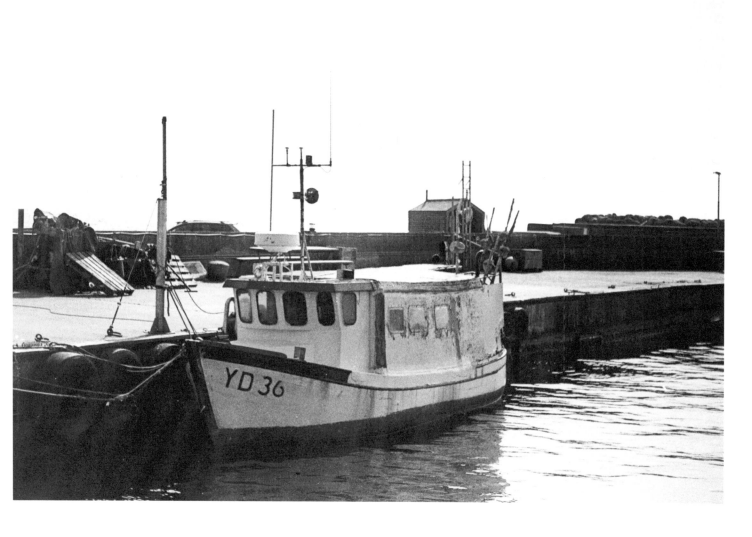

Kåseberga is a captivating and enchanting village that holds a multitude of attractions for visitors, encompassing its storied past and vibrant present.

Presently, Kåseberga stands as one of Sweden's most popular destinations, drawing in numerous visitors. The village has managed to preserve its authentic charm and ambiance, with its idyllic streets and quaint fishing huts adorning the harbor.

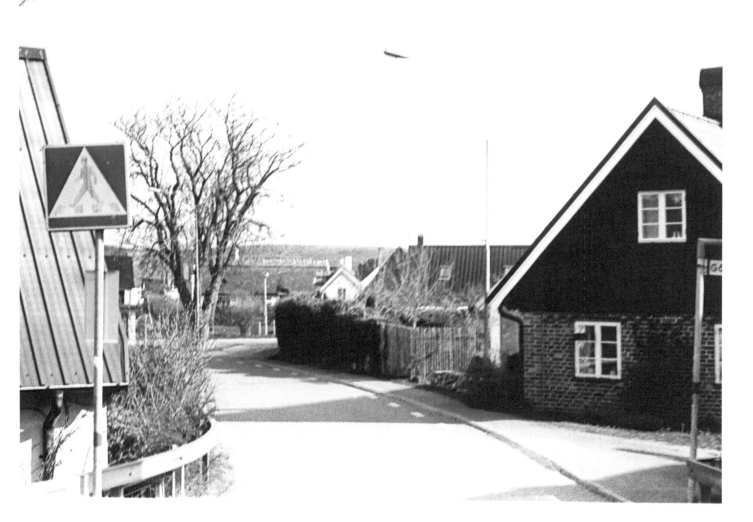

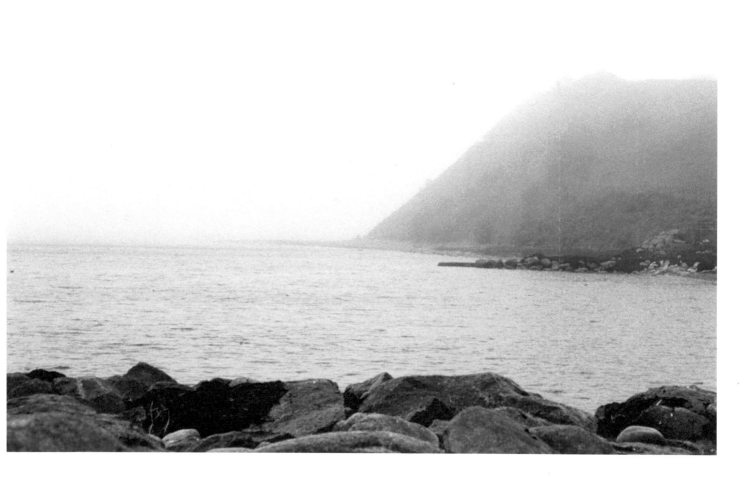

16

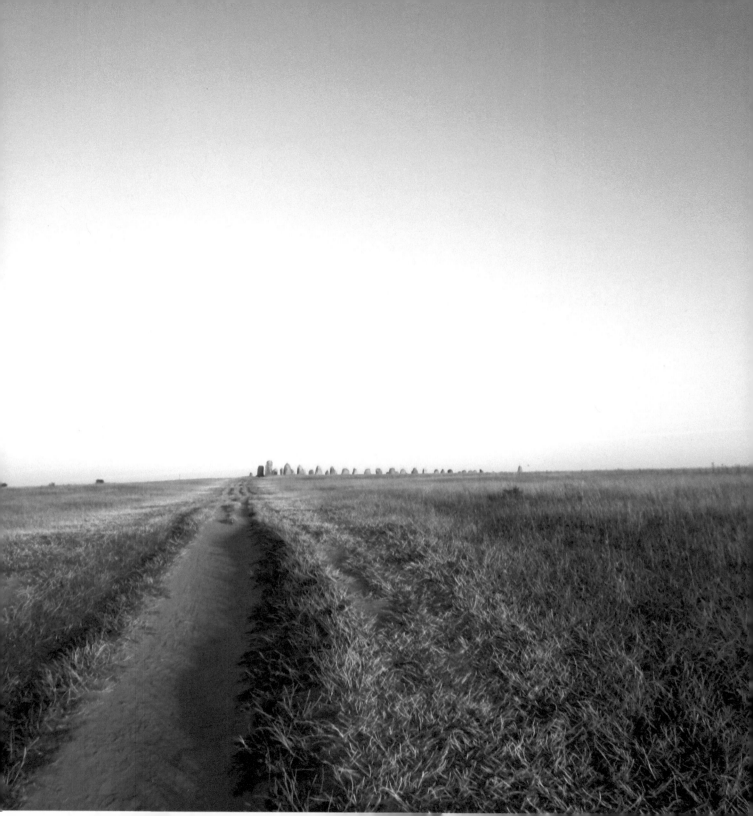

At Ale stenar, I stand in tranquility, attuned to the whispers of silence. Here, one can listen to the gentle rhythm of the heart and inhale the essence of timeless tales.

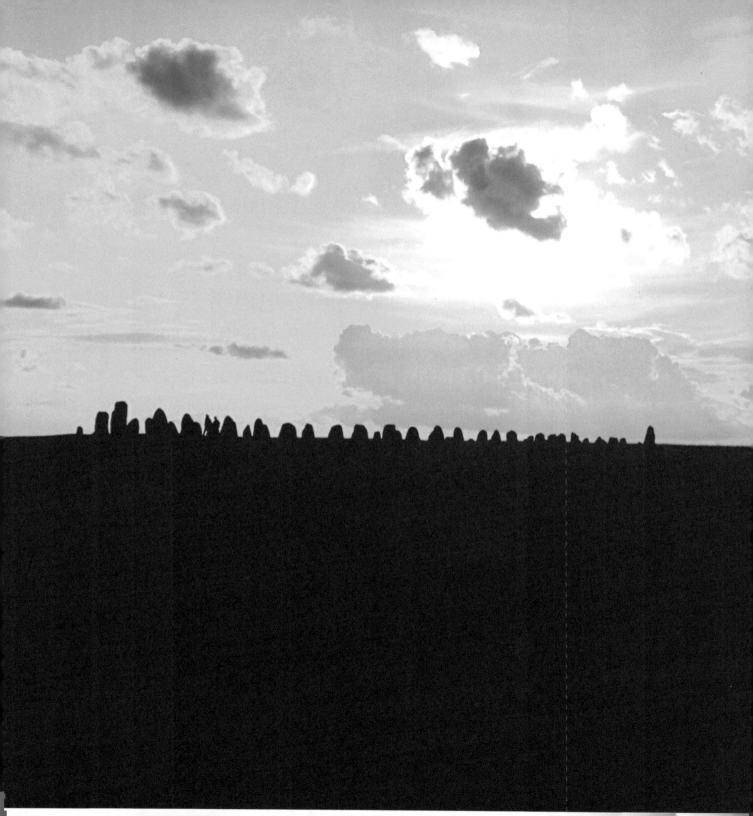

In the luminous night, they stand majestic and silent, the stones once raised high.

The enchantment of the summer solstice is exquisite, as the ancient stones mirror the golden hues of the sun. And in that fleeting moment, one can glimpse a sense of eternity.

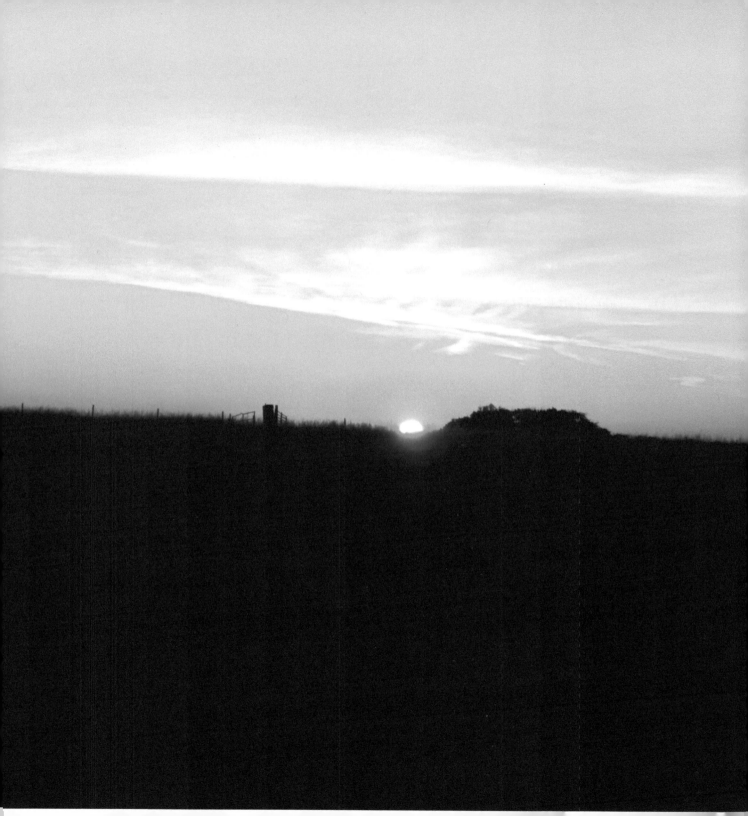

The summer solstice at Ale stenar—a day to cherish, when the sun reaches its zenith upon the height of Kåsehuvud.

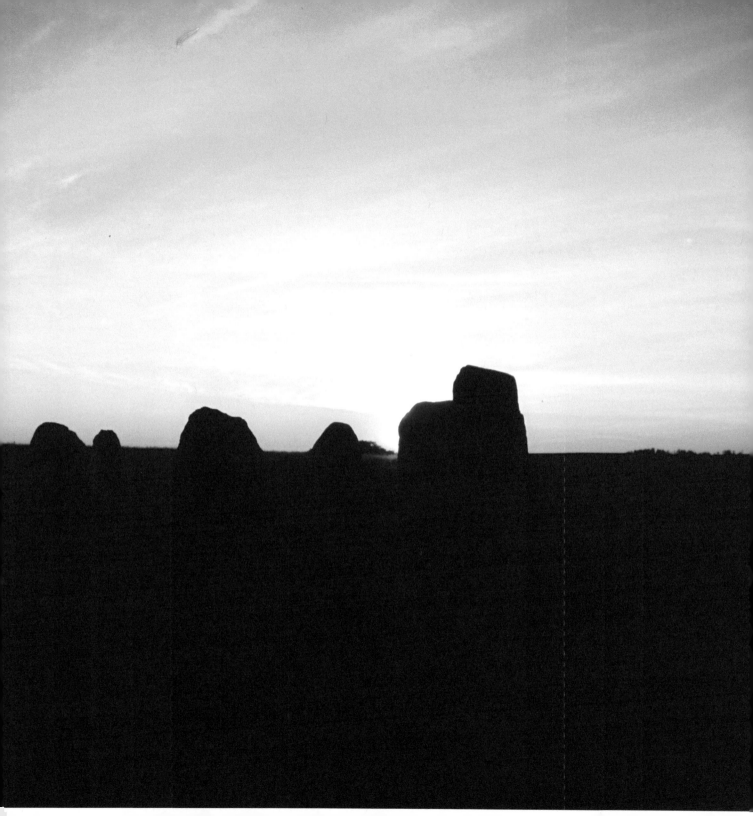

24

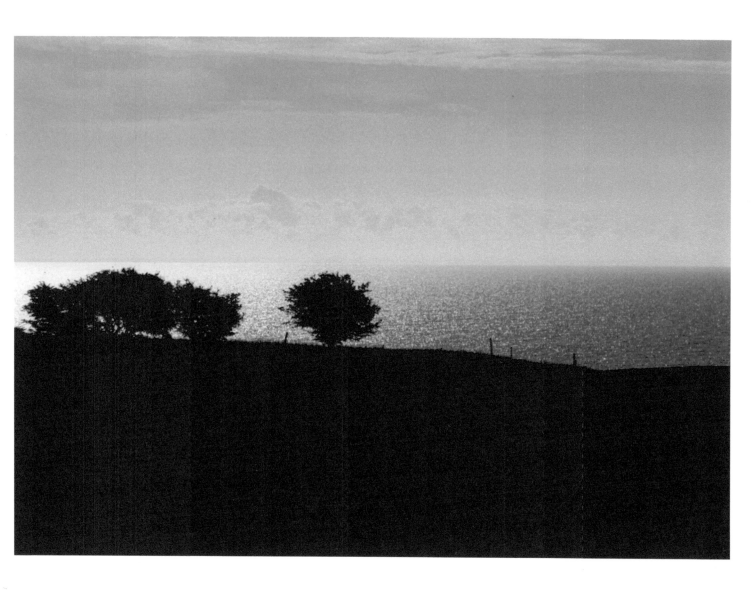

As the fog gracefully wraps around the ancient stones, a sense of mystery charm fills the air.

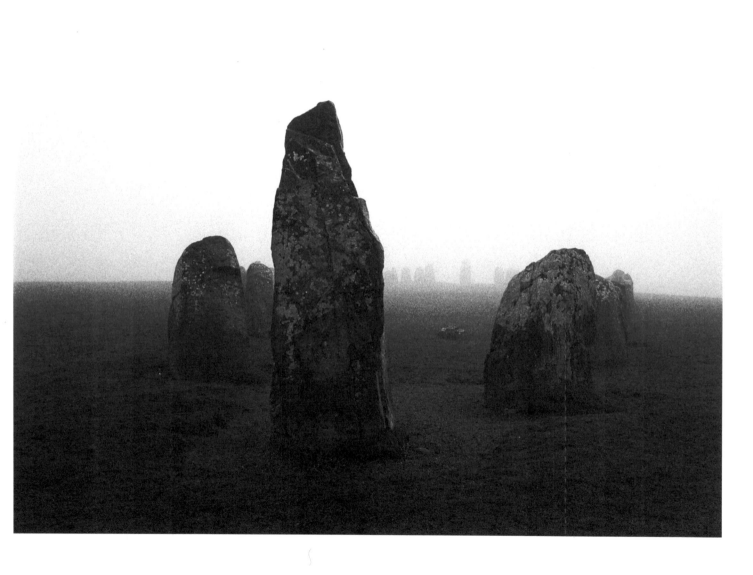

The hazy veil softens the edges, casting an otherworldly glow upon the weathered surfaces. It is as if the stones themselves come alive, shrouded in a delicate dance between light and shadow.

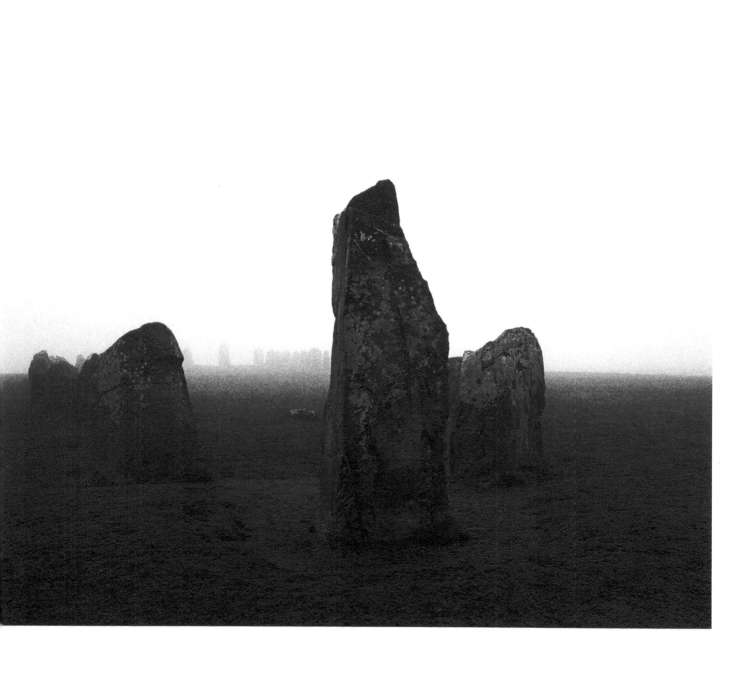

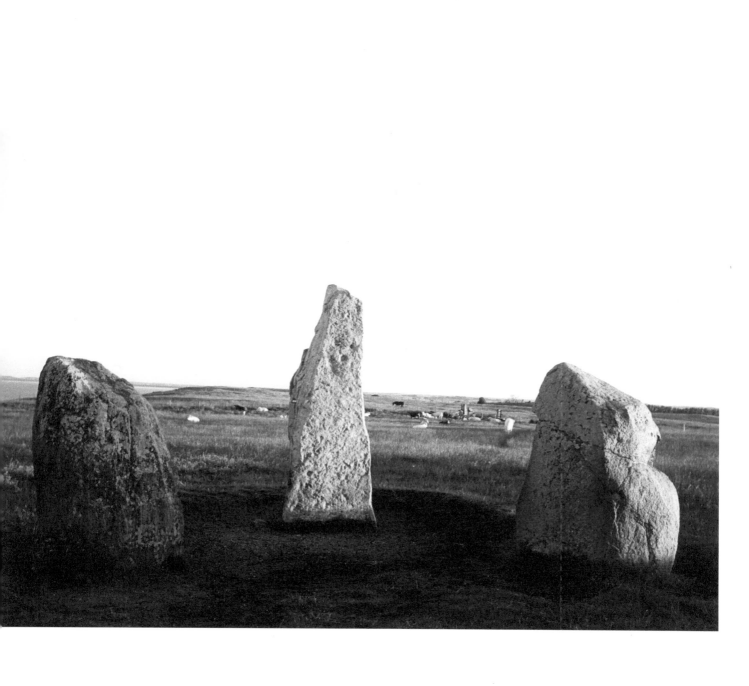

Moments of eternity on Ale stones.

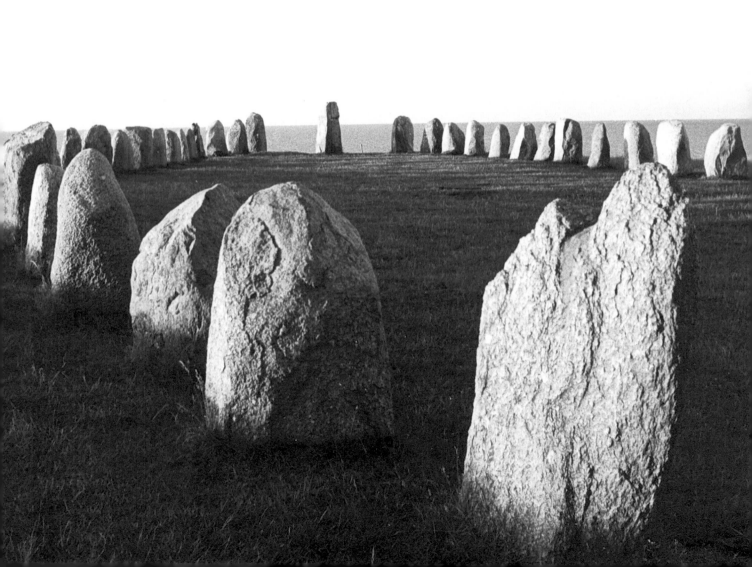

34

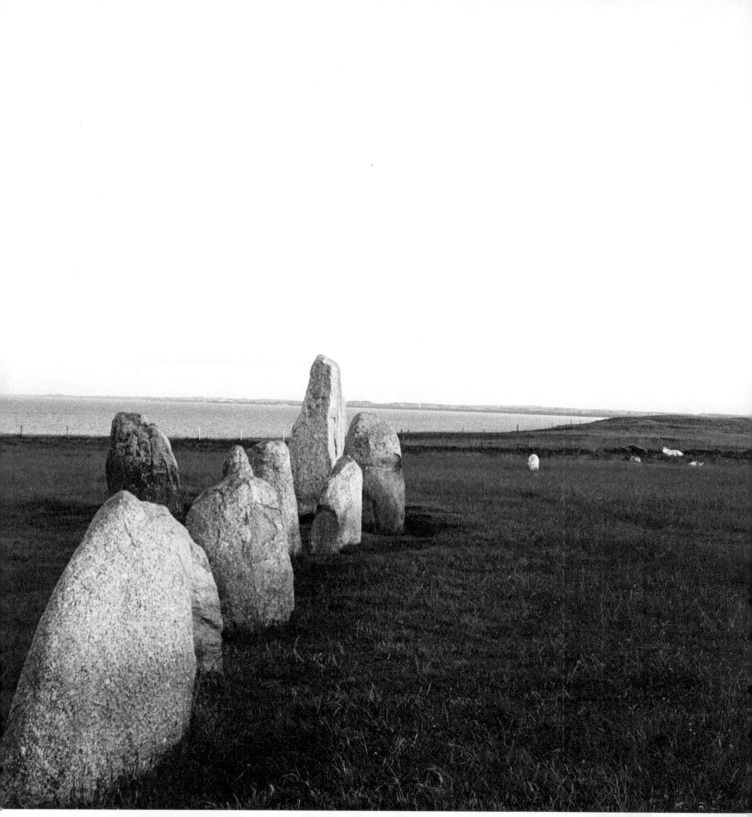

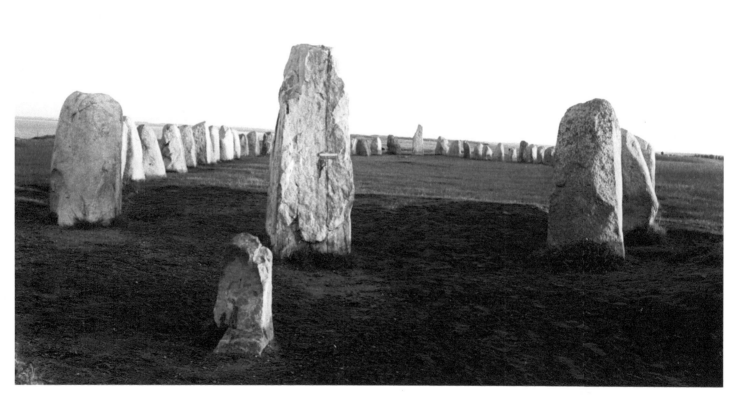

In the afternoon glow, a picturesque scene unfolds around Ale's Stones.

Flocks of sheep wander freely, among the ancient stones. Against the backdrop of the sea, they graze peacefully, their soft woolly coats blending harmoniously with the surrounding grasses.

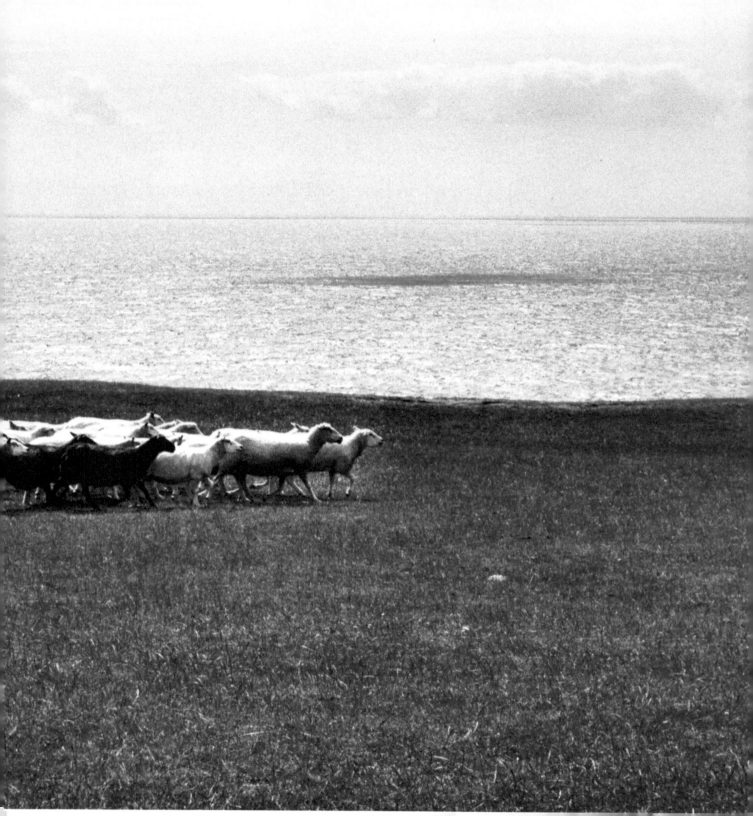

With each nibble, they create a rhythm, as if nature herself is composing a soothing symphony.

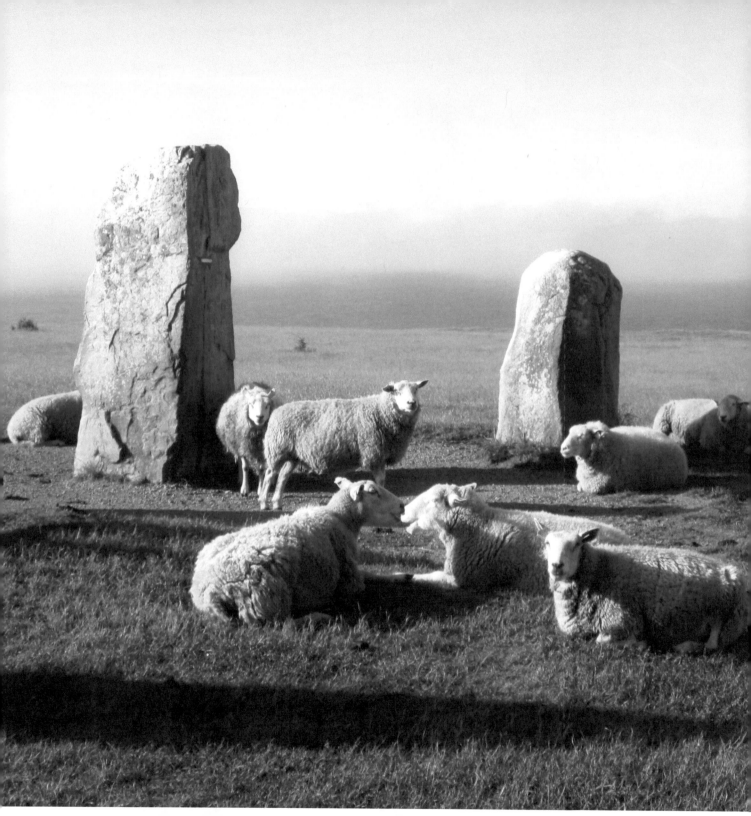

The timeless union of the grazing sheep and the ancient stones paints a tranquil portrait, inviting observers to embrace the simple beauty of the present moment.

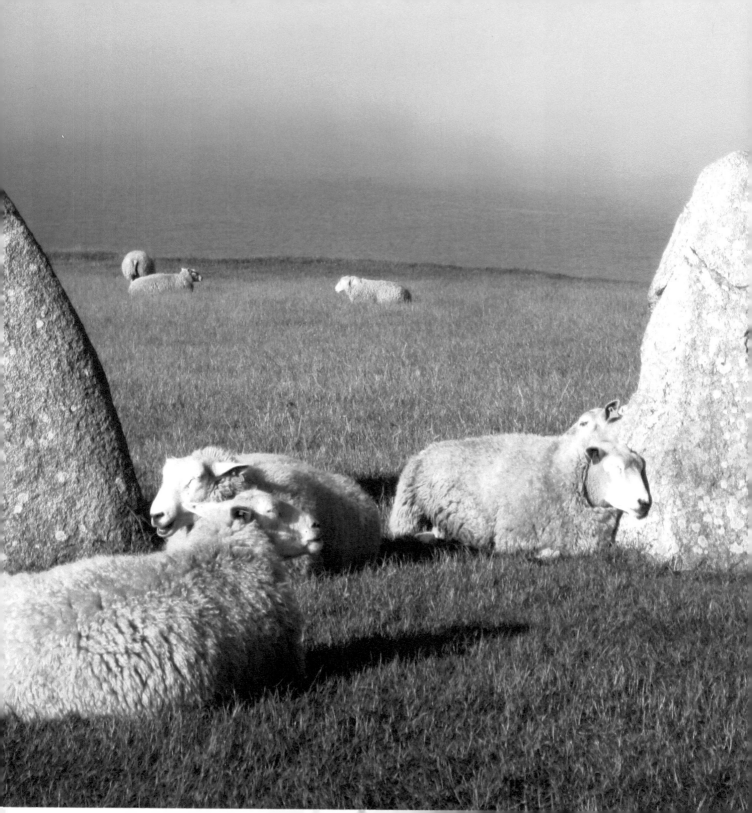

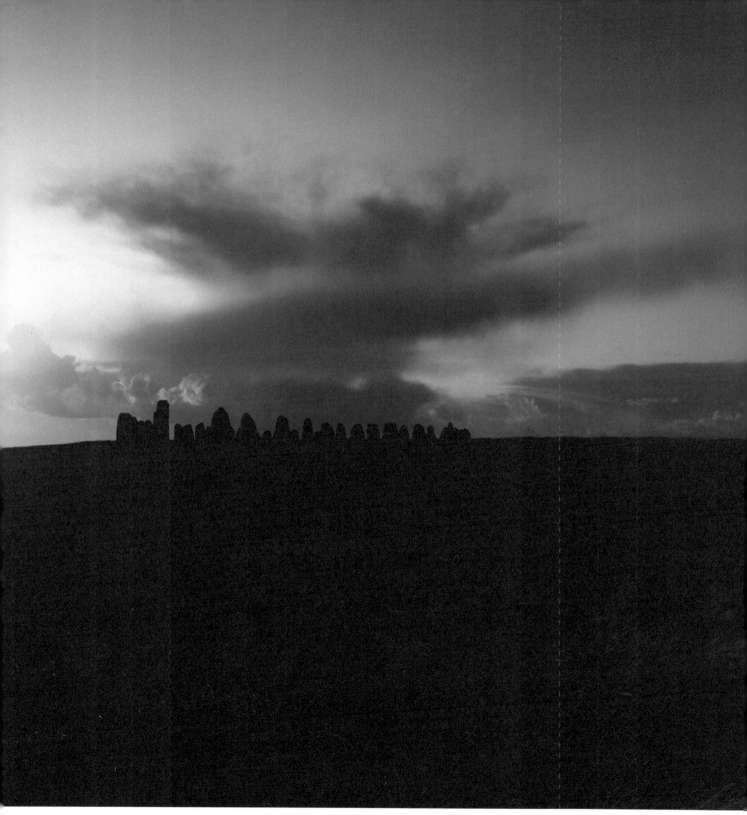

Contemplations of a standing stone

Within the stave stone at Ale stenar, a sea of thoughts stirs silently. Bearing witness to the grand events witnessed through the years.

The stone ponders upon human aspirations and the unfolding of destinies. It steadfastly oversees the place it calls home.

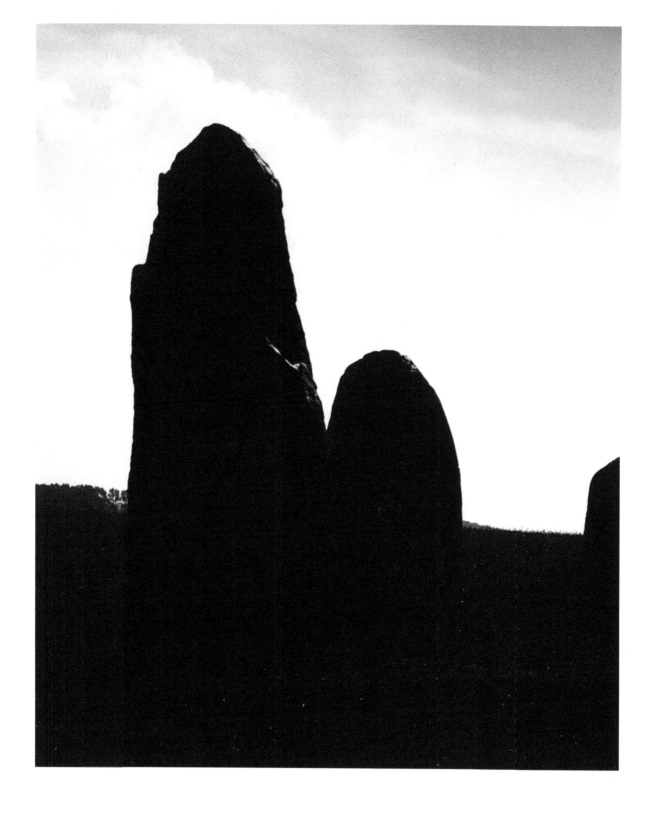

Through storms and sunlit days, through night's embrace, the touchstone ponders and contemplates. A symbol of eternal wisdom it remains, ever reflecting.

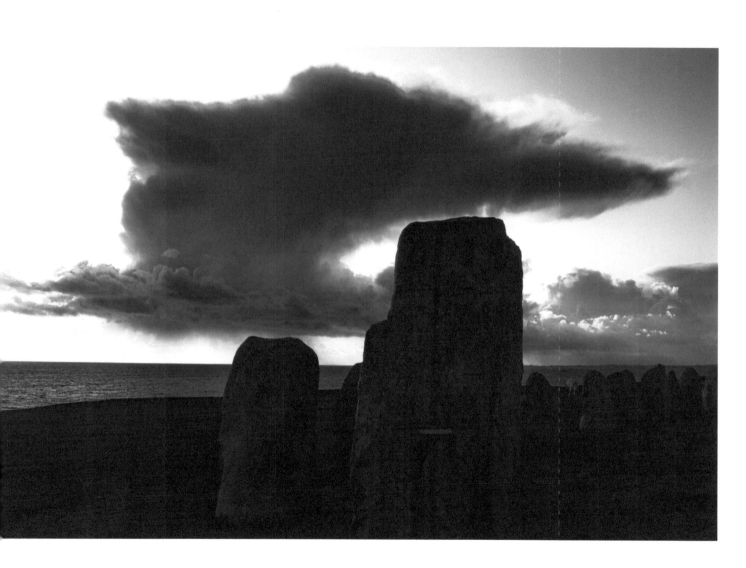

Through the mist, distant sounds become muffled, as if nature itself pays homage to the ancient stones. The silence amplifies the mystical atmosphere, inviting contemplation and introspection.

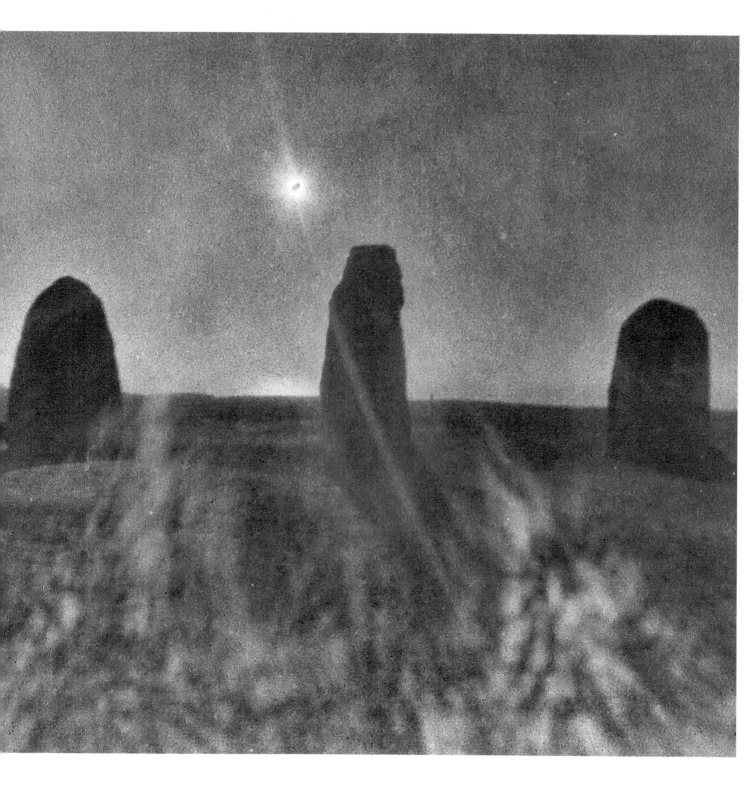

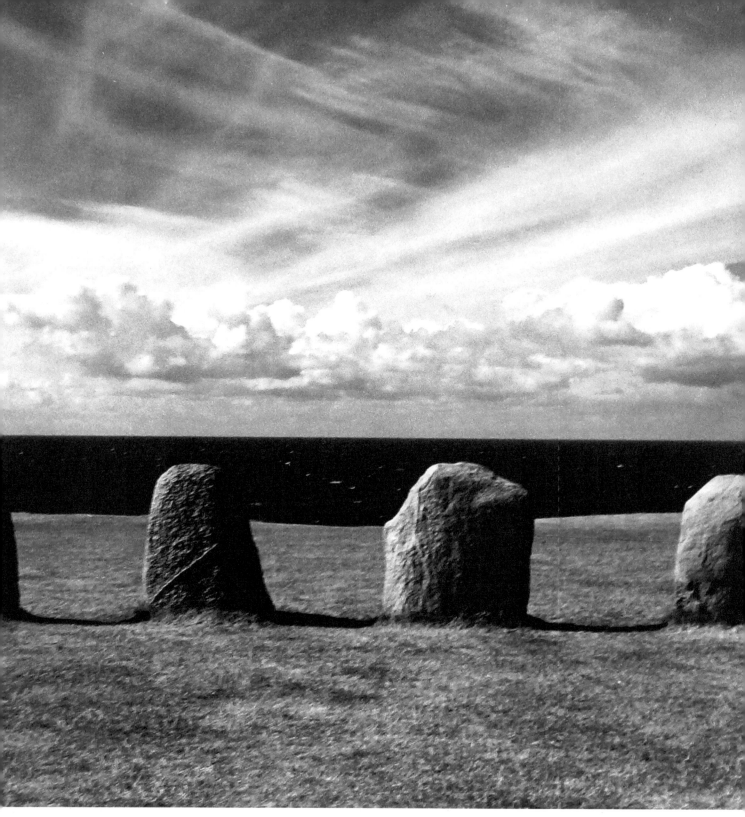

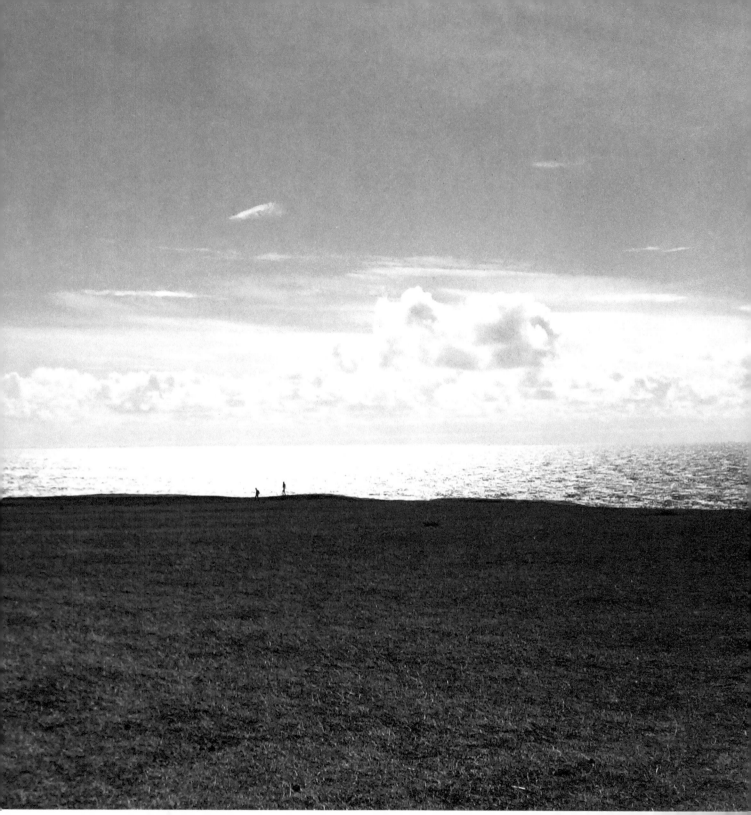

The mist gently envelops the Ale Stones, casting an ethereal veil upon their ancient form. Like a delicate embrace, the fog weaves its way around the weathered stones.

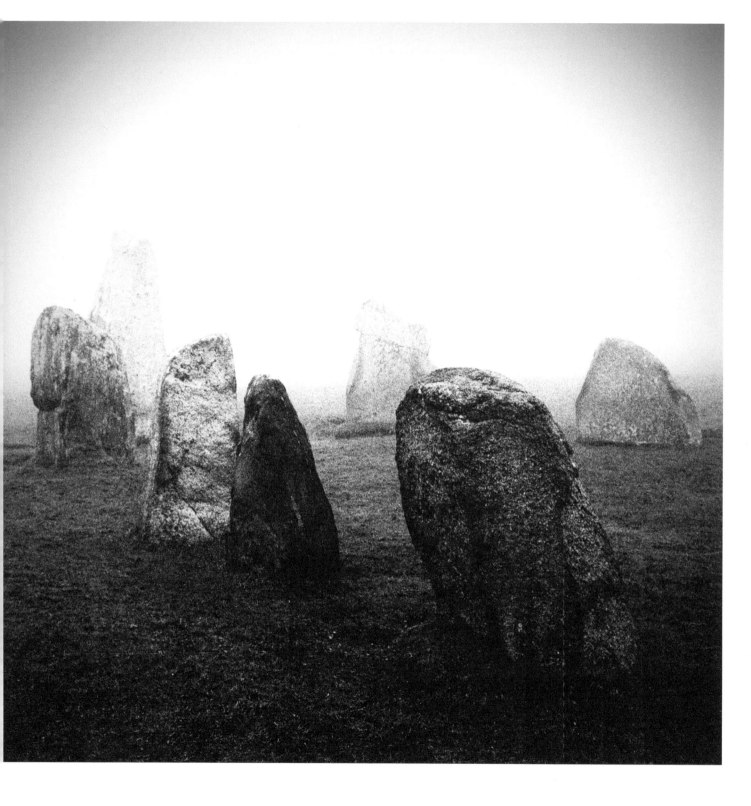

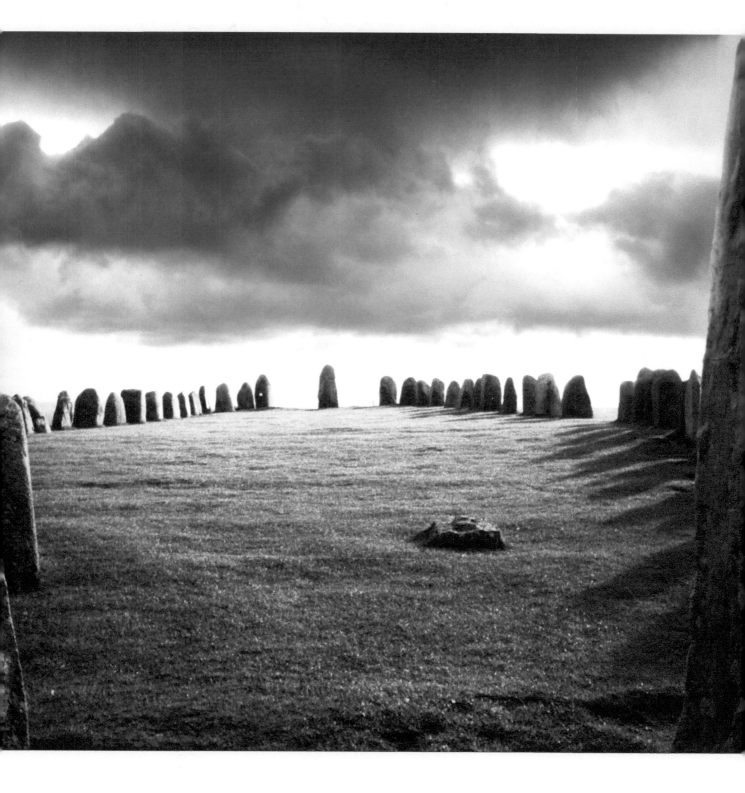

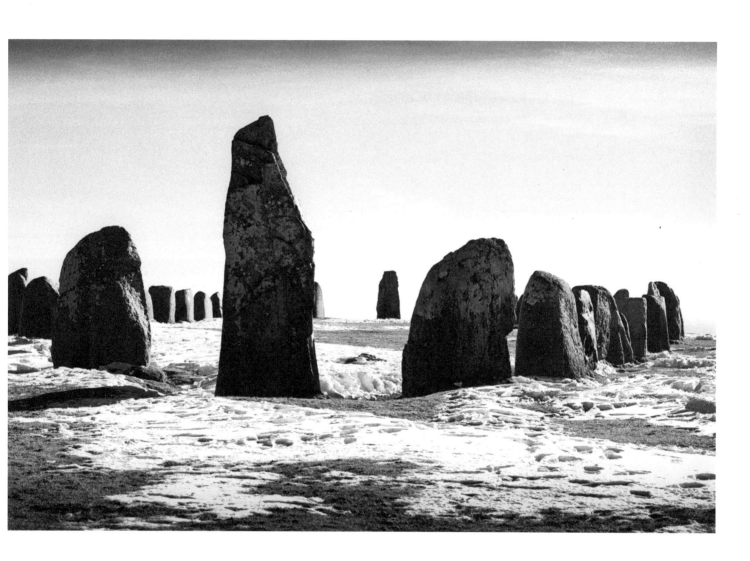

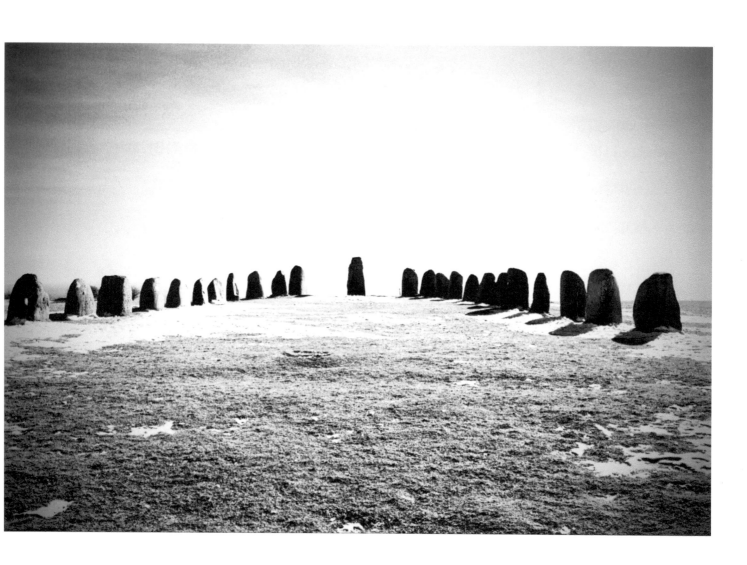

On the coastal edge where Ale meets the sea and the winds gust with might, stand the immense gray stones, steadfast in their sight.

They have witnessed centuries, heard the crashing waves roar, and retreated to silence once more, felt the sun's scorch and the night's icy core.

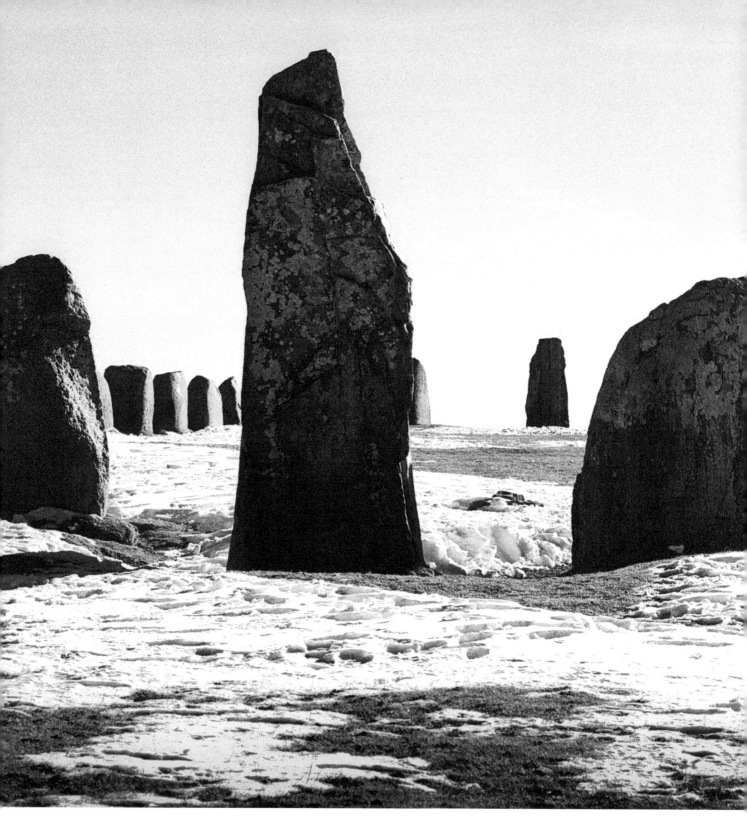

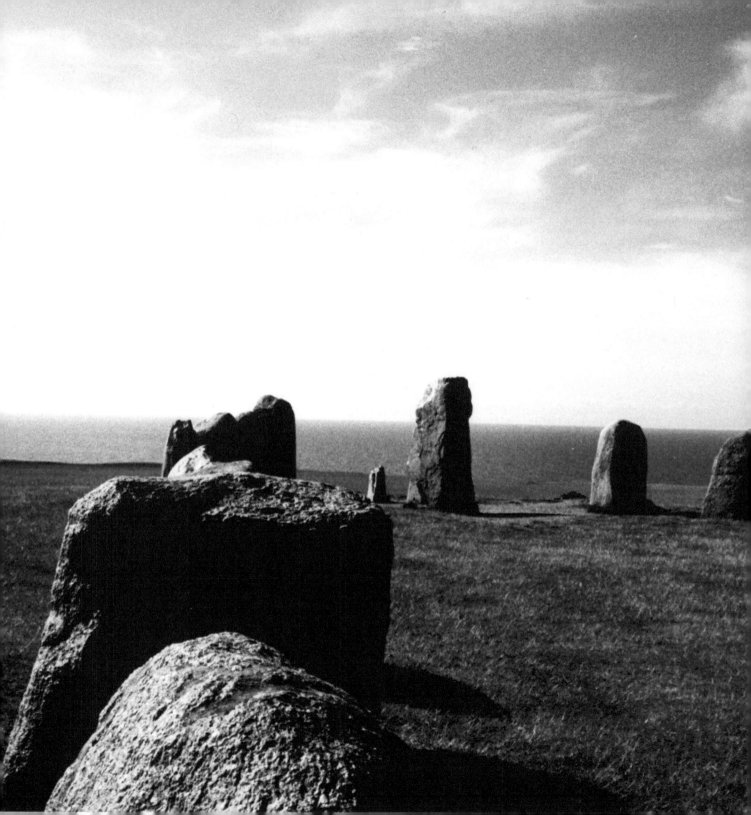

Toward Ale rocks, two hearts incline, standing united by the sea's melodic tune. Their love, unyielding as the sturdy rock, is bound by a powerful bond, ever in bloom.

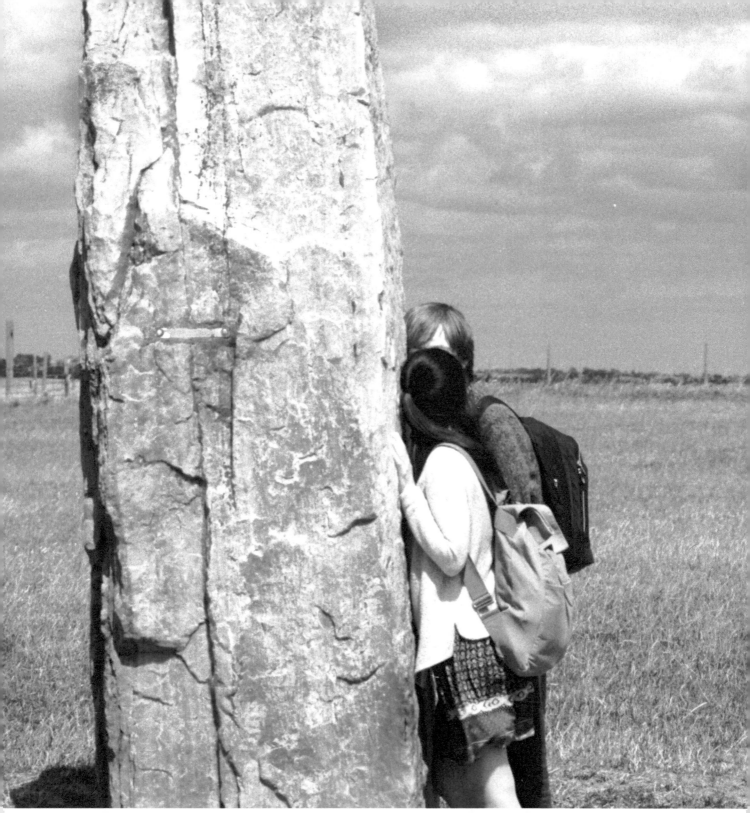

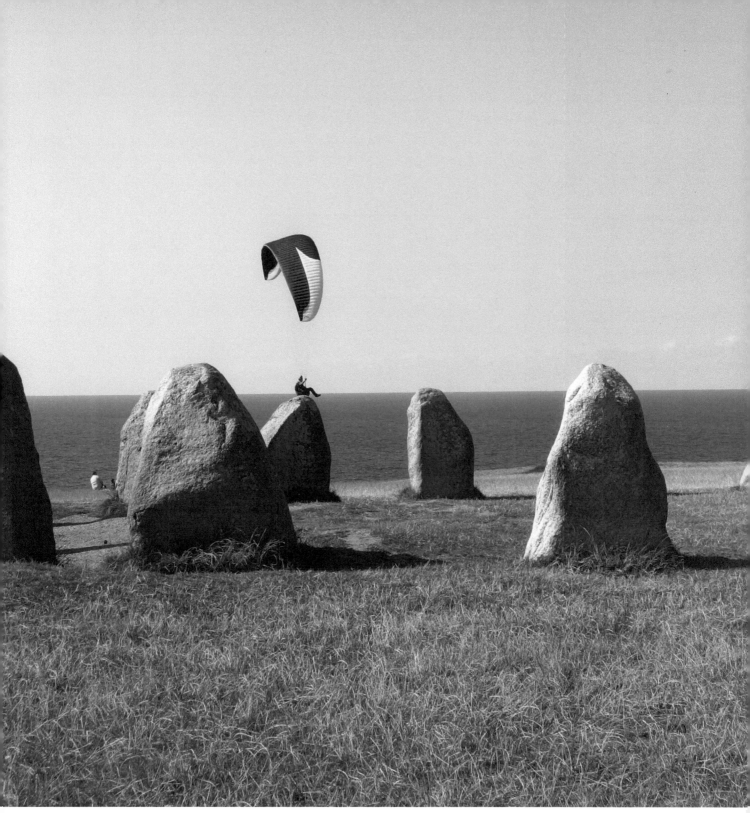

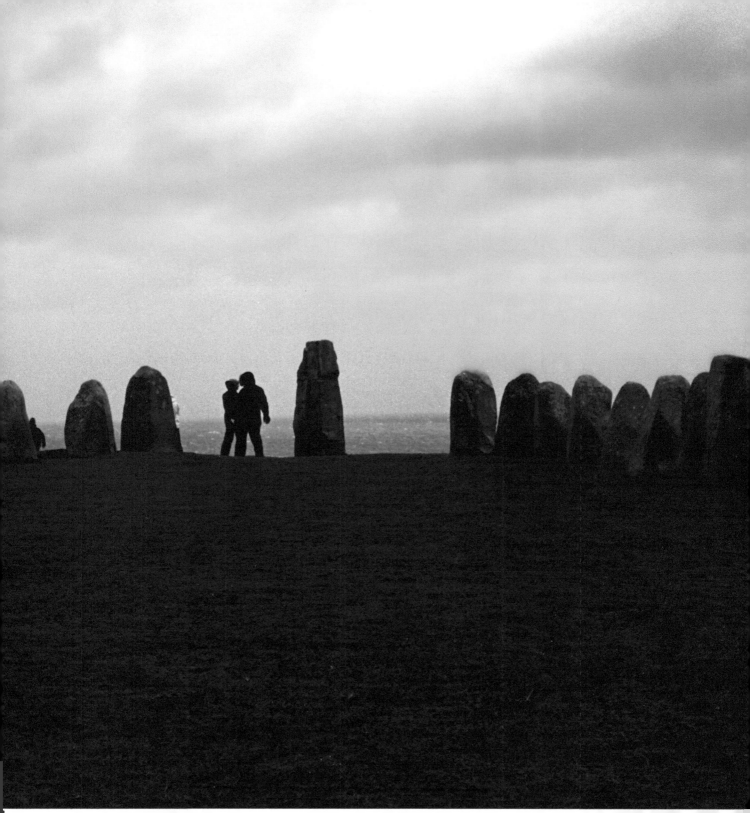

The joyous laughter of children fills the air at Ale stones. They embark on a journey through history, feeling like wanderers in a bygone era. The magnificence of the stones and the mystical presence of ancient deities ignite their playful spirits and their imagination.

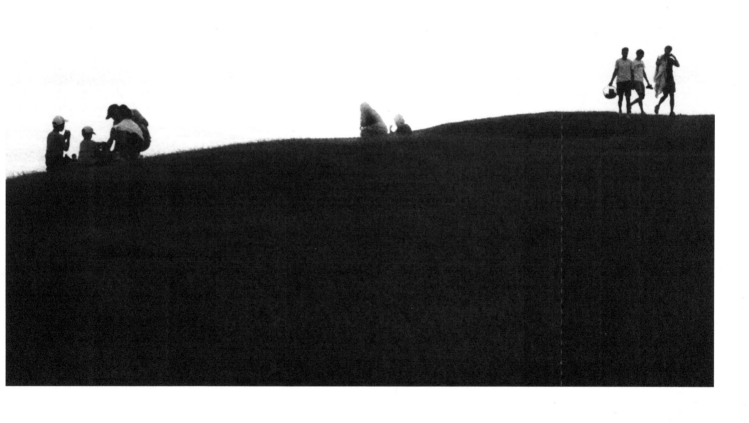

Two elderly men stand and gaze out over the sea.

They speak cheerfully about the old memories they share and feel that life has just begun. They believe there is still so much to rejoice in.

As the salty breeze caresses their faces, their eyes twinkle with nostalgia and joy. With every wave crashing against the shore, they reminisce about the adventures they embarked on, the laughter they shared, and the challenges they conquered side by side.

In their lively conversation, they express gratitude for the experiences that have shaped them, for the wisdom gained over the years. They revel in the beauty of the present moment, finding solace in the serene expanse of the Baltic sea that stretches endlessly before them.

With smiles etched on their weathered faces, they speak of the dreams that still dance within their hearts. They vow to seize every opportunity, to savor each precious instant, for they believe that life's wonders are not bound by age but are there to be cherished at every stage.

In the company of the sea's rhythmic melody and the companionship of a lifelong friend, they find solace and affirmation. Their spirits soar, fueled by the belief that there is so much more to come, so many reasons to celebrate, and countless stories yet to be woven into the tapestry of their lives.

And as the sailboats sway in the distance, carried by the winds of possibility, these two kindred souls stand tall, their hearts brimming with hope, grateful for the journey they have shared and eager to embrace the remarkable chapters that lie ahead.

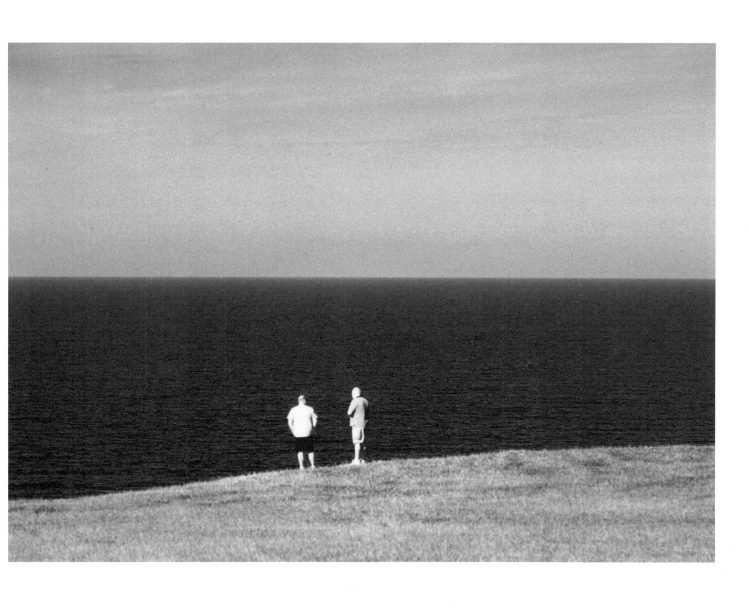

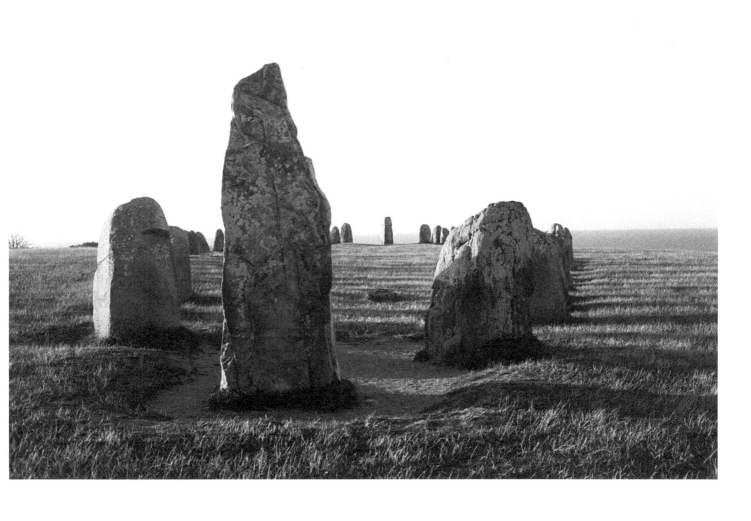

People sit and gaze out over the sea at Kåseberga. They feel the wind against their cheeks and watch as a sailboat slowly tacks against the wind towards a distant harbour.

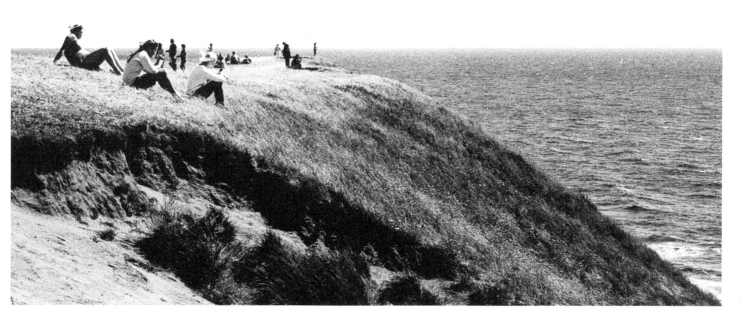

The Ale stones is a remarkable and enigmatic ship setting.

Situated above the village of Kåseberga in Skåne, on the Swedish south coast, it ranks among Sweden's most visited destinations. The ship setting comprises 59 large stones meticulously arranged in the shape of a ship. These stones, weighing around 5 tons each, tower 32 meters above sea level on Kåsehuvud, offering a breathtaking view of the Baltic Sea.

This preserved shipwreck is the largest of its kind in Sweden, measuring approximately 67 meters in length and 19 meters in width. The majority of the stones in the ship setting are made of granite from Kåsebergaåsen, while the stave stones and altar stones are crafted from Hardeberga sandstone. The rudder, on the other hand, is fashioned from white quartzite.

The ship setting dates back to the Vendel period, constructed between the years 540 and 790.

There exist numerous theories regarding the purpose behind the construction of Ale stones.

One prevailing theory suggests that they served as a site for religious or ceremonial activities. Another hypothesis proposes their utilization as an astronomical calendar. Additionally, there is speculation that burials took place at the site during the Iron Age.

Over the years, Ale stones has captivated archaeologists, leading to various investigations and studies.

Modern research has included georadar surveys of the ground beneath the stones, which have unveiled the possibility of undiscovered stones yet to be found.

Somerled Karlsson is a photographer who possesses a specialization in capturing nature's motifs using antique cameras. His portfolio is distinguished by a relentless quest for beauty and visual potency.

Somerled possesses a remarkable talent for crafting images that evoke a sense of tranquility and serenity, all while maintaining an exquisite aesthetic appeal. Fuelled by a deep passion for nature and an unwavering attention to detail, Somerled serves as an inspirational figure within the realm of photography.

Somerled's captivating photographs are available for purchase through the Fine Art America platform via his website at **www.somerled.com**.

Explore his gallery and discover the opportunity to bring the beauty of his works into your own space.

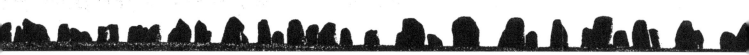